VELÁZQUEZ

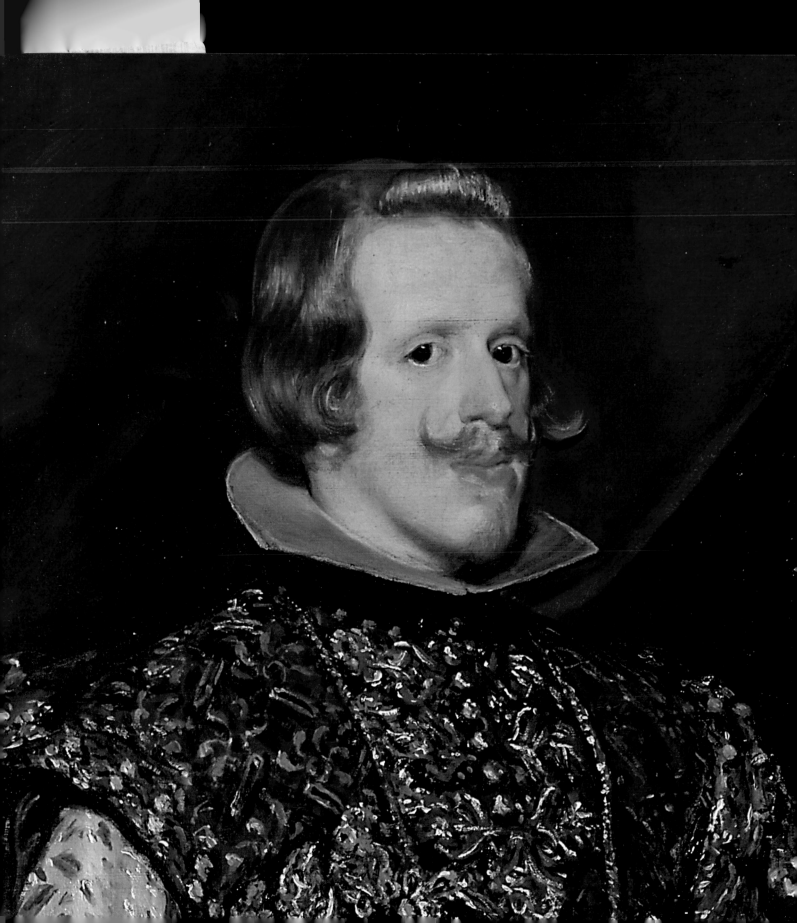

VELÁZQUEZ

Leah Kharibian

NATIONAL GALLERY COMPANY, LONDON ·
DISTRIBUTED BY YALE UNIVERSITY PRESS

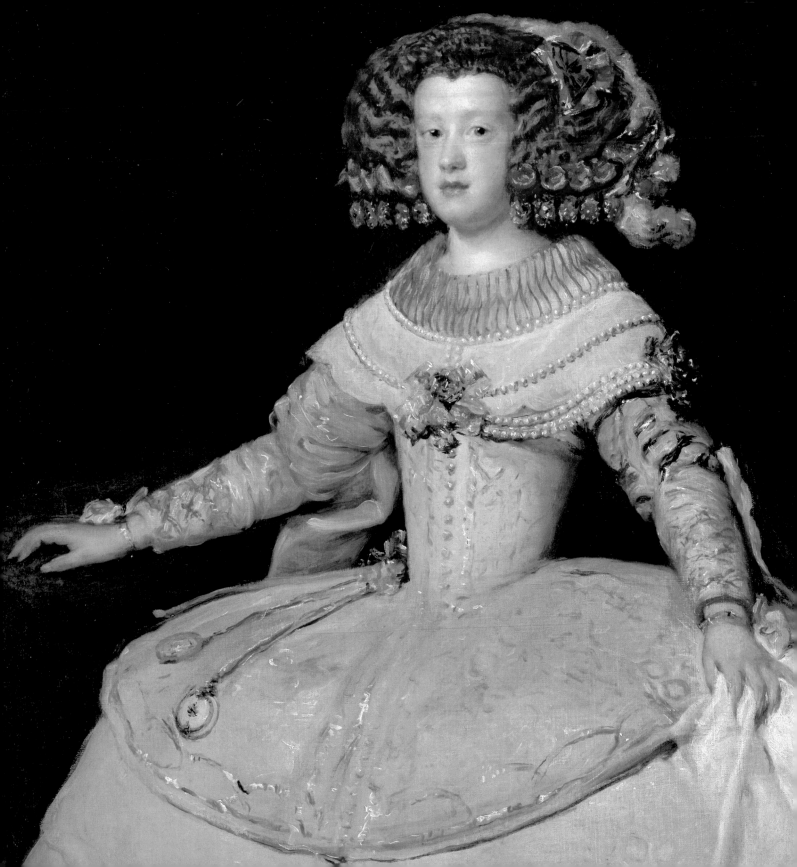

FEW PAINTERS COMMAND the universal admiration of other artists, as well as scholars, philosophers, poets and ordinary people, as does Diego Velázquez (1599–1660). His paintings astound all who stand before them because, whether portrait, saint, or mythological figure, Velázquez presents us with a compelling sense of the physical and psychological presence of the people he depicts. When confronted at a distance by such visual 'truth', it is only natural to move closer, to attempt to learn how the illusion is achieved, and then 'reality' dissolves into the most concise and artful brushwork. This paradox is at the heart of Velázquez's lifelong examination of the relationship between art and nature.

Velázquez's artistic journey began in his native Seville, where in the studio of his future father-in-law, the scholar-painter Francisco Pacheco, he was introduced to the serious study of art as an intellectual rather than a manual pursuit. Pacheco ensured that his greatest pupil came to the attention of the royal court at Madrid and, after his appointment as Philip IV's painter, his innate talent developed as he learnt from the Habsburg's extraordinary collection of European art as well as two trips to Italy. While he absorbed many lessons from the art of the past and present, Velázquez always had a distinctive manner, not only in the way he applied paint, but in his approach to his subjects. He viewed the world with objectivity, but also with great gravity and humanity that communicates profoundly across centuries.

The story of Velázquez's genius and development as an artist is told by this book and by the exhibition it accompanies. The esteem for Velázquez in Britain is attested to by the collection of the National Gallery, the largest and most diverse outside the Museo Nacional del Prado, as well as by the many fine examples of his art in public and private collections in this country. We aim to show these national treasures in the context of Velázquez's career and, to achieve this, we have depended on many lenders, but most particularly the Prado, and we are immensely grateful for their generosity.

We would also like to express our gratitude to Leah Kharibian, the author of this book, for her eloquent contribution, and to Dr Dawson Carr, Curator of Spanish and Later Italian Paintings, who has overseen the exhibition. Finally, we would like warmly to thank Abbey for their sponsorship of the exhibition.

CHRONOLOGY

SEVILLE

1599 Diego Rodríguez de Silva y Velázquez is born in Seville, southern Spain.

1610 *1 December* Aged 11 Velázquez is apprenticed to the painter Francisco Pacheco (1564–1644) with whom he lives and works for the next six years.

1617 *14 March* Velázquez is licensed to practise as a master painter.

1618 *23 April* Velázquez marries Pacheco's daughter, Juana.
An Old Woman cooking Eggs (page 8)

1619 Birth of Velázquez's first daughter, Francisca.

1620 Arrival in Seville of Mother Jerónima de la Fuente (page 10)

1621 Philip IV (1605–1665) ascends the Spanish throne aged 16.

1622 *April* Velázquez's second daughter Ignacia is born.
Velázquez travels to Madrid in the hope of winning the patronage of the new king. He fails and returns to Seville.

MADRID

1623 Returning to Madrid Velázquez comes to the attention of the Sevillian, Count Olivares, King Philip IV's powerful first Minister.
August Velázquez paints his first portrait of Philip IV.
6 October Velázquez is appointed one of a number of official painters to the royal court and brings his family to live permanently in Madrid.

1627 Philip IV initiates a painting competition among his leading court artists. Velázquez, the youngest, is declared the winner.

1628 Velázquez is promoted to the position of *pintor de cámara* – chief court painter – with responsibility for creating portraits of Philip IV, the royal family and chief courtiers.
October The renowned Flemish artist, Peter Paul Rubens, arrives in Madrid on diplomatic mission. Over the seven months of his stay Rubens inspires Velázquez to study the art of Italy first-hand.

1629 *The Feast of Bacchus* ('*Los Borrachos*') (page 17)

ITALY

1629 *28 June* At Rubens's prompting Philip IV grants Velázquez leave to study in Italy and provides him with a generous bursary. Velázquez visits Genoa, Venice and other Italian cities before settling in Rome.
17 October In Velázquez's absence a new heir to the Spanish throne, Baltasar Carlos, is born in Madrid. Philip IV refuses to let any artist paint his son until Velázquez returns.

1630 Velázquez stays in Rome until the autumn.
Apollo at the Forge of Vulcan (page 15)

MADRID

1631 Velázquez returns to Madrid via Naples.

1634–5 Velázquez paints a series of large-scale works for the Hall of Realms at the new Buen Retiro Palace including the *Philip IV on Horseback* and *Prince Baltasar Carlos on Horseback* (pages 20–3)

1635–40 Rebuilding and refurbishment of the Torre de la Parada, the royal hunting lodge. Pictures by Rubens provide the bulk of the decoration but it seems Velázquez also contributes work including *Philip IV hunting Wild Boar* ('*La Tela Real*'), *Francisco Lezcano* and *Mars* (pages 24–9)

1643	Velázquez begins to paint less frequently as successive promotions at court require him to spend time attending to the upkeep of the king's apartments and the display of the royal collection.

1644 *6 October* Death of Queen Isabella.

1646 *9 October* Sudden death of the heir to the throne, Baltasar Carlos, aged 17.

ITALY

1649 *11 March* Velázquez arrives in Italy on a mission to acquire art for the royal collection and to find Italian fresco artists to decorate the Spanish royal palaces.
29 May After visiting several Italian cities Velázquez arrives in Rome.
In Velázquez's absence Philip IV marries his niece, Mariana of Austria. In Seville Francisco Pacheco's *Arte de la Pintura,* which gives an account of Velázquez's early career, is published.

1650 *January* Velázquez is made a member of the Roman painters' Academy of Saint Luke followed in February by his appointment to the prestigious Congregazione dei Virtuosi.
November After repeated requests to return home Velázquez leaves Rome. He departs before the son he has fathered is born.
Pope Innocent X (page 32)
Monsignor Camillo Massimo (page 33)

1651 In Venice Velázquez acquires works by Titian, Veronese and Tintoretto for Philip IV.

MADRID

1651 *June* Velázquez arrives back in Madrid.
12 July Birth of the Infanta Margarita, the first child of Philip IV's new marriage.

1652 *8 March* Velázquez is appointed to the most senior court post of *aposentador mayor de palacio* – Chamberlain of the Royal Palace.

1656 Velázquez works for several months on a new display of the royal art collection at the royal palace and monastery, El Escorial.
The Family of Philip IV ('Las Meninas') (page 42)

1657 *28 November* Birth of the short-lived heir to the throne, Felipe Próspero (1657–1661).

1659 *27 November* Velázquez is made a knight of the Order of Santiago only after the intervention of the Pope at the king's request.
Infante Felipe Próspero (page 40)
Infanta Margarita Teresa in a Blue Dress (page 41)

1660 *31 July* Velázquez suddenly falls ill, and dies a few days later on 6 August.

1665 Death of Philip IV of Spain, aged 60.

VELÁZQUEZ IN SEVILLE

IN 1599 DIEGO RODRÍGUEZ DA SILVA Y VELÁZQUEZ was born in Seville, a wealthy inland port in southern Spain. At the age of 11 he was apprenticed to the painter, theorist and intellectual Francisco Pacheco with whom the young artist lived and worked for the next six years. His career began in earnest when in 1617 Velázquez was licensed to practise as a master painter, and he continued to work in the city until 1622.

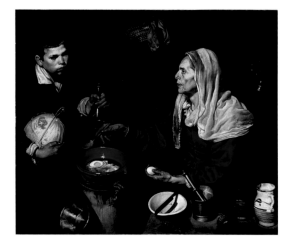

1 *An Old Woman cooking Eggs,* 1618
Oil on canvas, 100.5 × 119.5 cm
National Gallery of Scotland, Edinburgh

1 Velázquez displayed an extraordinary talent for painting right from the start. *An Old Woman cooking Eggs,* which is one of his earliest known works, was painted in his native Seville in 1618 when he was just 19 years old. It shows a humble kitchen in which an old woman seated at a stove looks up at a boy arriving with a melon and a carafe of wine. In choosing this everyday subject the young Velázquez drew inspiration from pictures known as *bodegones,* a term derived from the Spanish word *bodegón* – a wine-cellar where cheap food and drink could be bought. In the hands of other artists *bodegones* tended to show ordinary, often joking, figures in kitchens and taverns amid heaped still lifes of colourful food and cooking utensils. These pictures were vehicles for artists to display their skill in creating an illusion of reality and often had a moralising content. In *An Old Woman cooking Eggs* Velázquez created a much darker and less cluttered version of the type, where each object is picked out by an intense light. And while it seems he studied the figures and objects in this picture from life – the same models appear in other *bodegones* he made around this time – his vivid naturalism and use of paint immediately marked him apart as a unique talent. Here Velázquez does not try to set down his observations in laborious detail. Rather, he seems to be using his technical mastery to make paint *suggest* the world as we see it. With the cooking eggs, for example, Velázquez uses simple brushstokes to capture the moment at which the whites of the eggs coalesce and turn opaque in the liquid in which they are being cooked. It is with similar apparent ease that through a few highlights on the cooking dish, the woman's fingernails and the glass carafe, Velázquez tells us so much about their different surface textures.

Although *An Old Woman cooking Eggs* depicts a low-life world, the subject in no way lacked ambition as serious art. Velázquez's teacher and father-in-law, Francisco Pacheco, with whom the young artist lived

and worked for many years as an apprentice, introduced him to a learned circle of writers and scholars. This group would have been familiar with the Spanish literature that celebrated the nobility of the humble. In the years Velázquez remained in Seville he painted many *bodegones* in which he invests his figures and the world they inhabit with tremendous dignity.

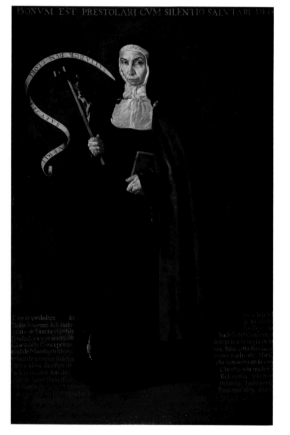

2 *The Venerable Mother Jerónima de la Fuente*, 1620
Oil on canvas, 162.5 × 105 cm
Private collection, Madrid

2 As an important religious centre, most painters in Velázquez's Seville were employed by the church. But like all artists in Spain, their status was very low, considered on a par with blacksmiths, carpenters and other manual craftsmen. Velázquez was determined to raise the status of painting and with *Mother Jerónima de la Fuente* it is possible to see how he used even the conservative format of the traditional portrait to display the power of his art.

As the later Spanish inscription at the bottom of the picture records, Mother Jerónima was a nun of the Poor Clares and was 66 years old when she arrived in Seville on her way to found the first convent in the Philippines. In this, the second of two versions, Velázquez dazzles the viewer by capturing the zeal that helped this extraordinary woman succeed in her long and dangerous mission. Despite the concealing nature of the nun's habit, the artist uses the exposed areas of Jerómina's skin to great effect. He shows the nun gripping the crucifix and the rules of her order with exceptionally firm hands while in her eyes he catches the glint of a steely intelligence. The Poor Clares took a vow of silence, referred to by the Latin inscription at the very top of the picture which translates: 'It is good to wait with silence for the Salvation of God.' The banderolle, or scroll, unfurling from Mother Jerónima's firmly pursed lips notes: 'I shall be satisfied when thy glory shall appear.'

There is no doubt that Velázquez's tremendous gifts as a portraitist were appreciated from the outset and his talents were destined to take him beyond Seville. For a Spanish artist of ambition the only place to head for was Madrid – the centre of the royal court. In 1623 Velázquez got the chance to show his worth when he was granted permission to paint a portrait of the new king, Philip IV. This picture was declared so successful that Velázquez was made a court painter almost immediately, whereupon he left Seville permanently for Madrid.

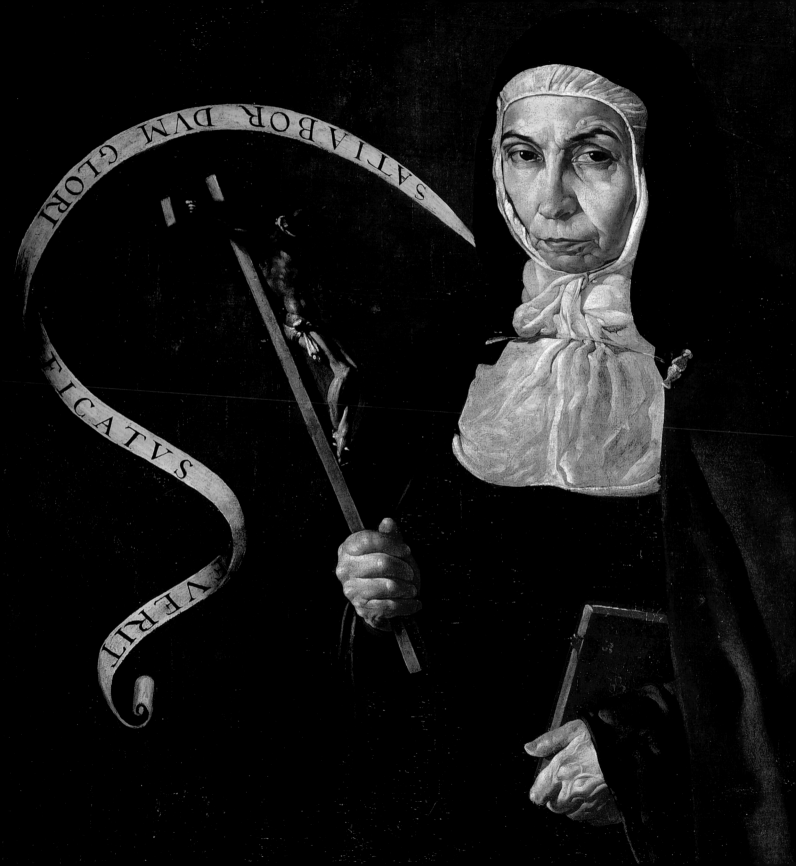

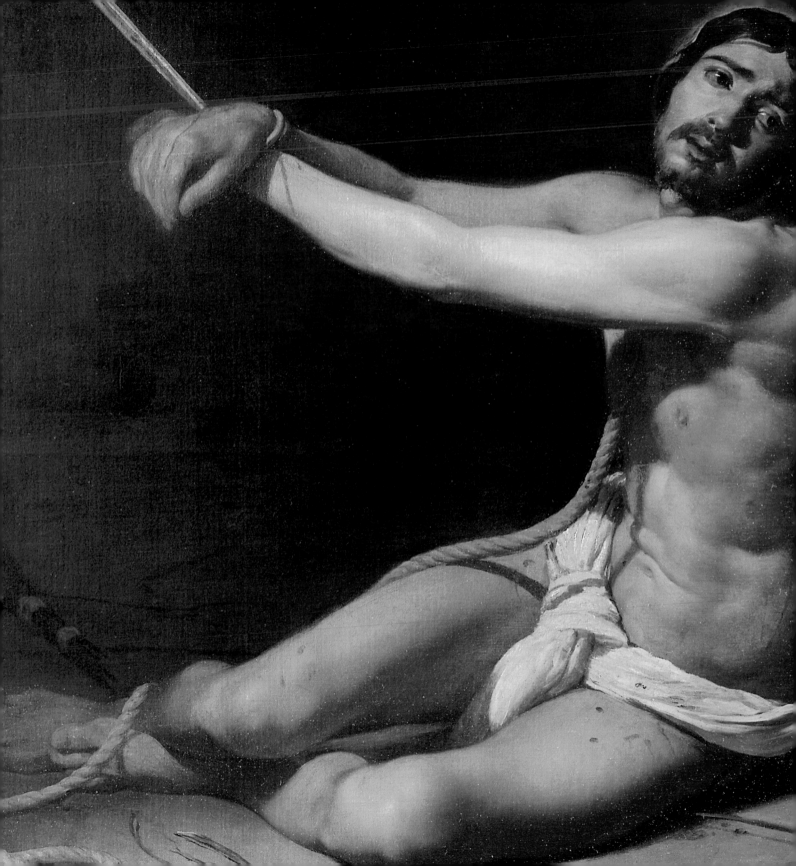

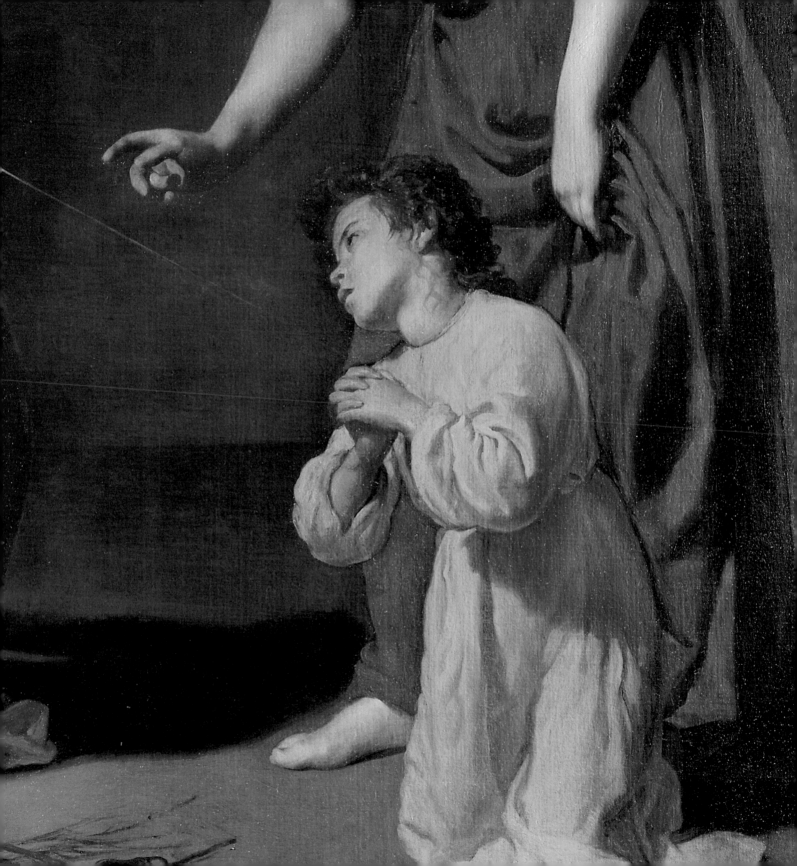

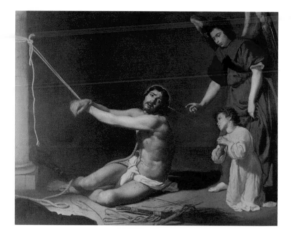

3 *Christ after the Flagellation contemplated by the*
 Christian Soul, probably 1628–9
 Oil on canvas, 165.1 × 206.4 cm
 The National Gallery, London

3 By the late 1620s Velázquez was well established at the Spanish Court where his astonishing technical abilities and intense naturalism saw off all rivals. Even in a religious work such as *Christ after the Flagellation contemplated by the Christian Soul* Velázquez could present a deeply mystical subject as if it were a scene taking place before the viewer's very eyes. In it Christ is shown after the Flagellation – the violent beating he received prior to his death upon the cross. His pain appears very real. He sits slumped with exhaustion from the ropes by which he is bound to the pillar while his blood spatters his skin, the loincloth about his hips and the ropes and flail that lie discarded on the floor. To the right, a guardian angel directs an equally real-looking child, representing the Christian Soul, to kneel in prayer. The look the child and saviour exchange is an intense one – Christ tilting his head with an imploring expression of anguish, the child responding by leaning forward with pitying, but impotent, sympathy.

On one level this picture can be seen as part of a Europe-wide movement in painting to make devotional pictures that would stir up viewers' pity and encourage them to pray. In the face of the growth of Protestantism, the Roman Catholic Church launched the Counter Reformation, by which means it hoped to win back the hearts and minds of the faithful – partly by encouraging a more emotional treatment of religious images. The strongly Counter Reformation quality of *Christ after the Flagellation* has made some suggest that it could only have been painted once Velázquez visited Italy, the heart of the Catholic Church, in 1629–31. The idealised, muscular body of Christ and the dramatic, stage-like use of space have also been presented as evidence of the influence of artists Velázquez would have seen in Rome. But, like many of Velázquez's pictures, the work is not dated and technical examination of the painting has lead to the discovery that it was painted on a dark reddish ground – a colour Velázquez adopted when he moved to Madrid but abandoned after he had been to Italy. While not in itself conclusive proof that *Christ after the Flagellation* was painted before he went, there are two other factors to consider. First, that the Spanish royal collection had important pictures by Italian artists that Velázquez could have studied. Second that in 1628 the Flemish artist Peter Paul Rubens – master of the heroic male nude – arrived in Madrid. Rubens may well have acted as the catalyst for pictures like *Christ after the Flagellation*, and renewed Velázquez's interest in the art of Italy.

IN THE SEVENTEENTH CENTURY it was considered essential for artists of ambition to study the art of ancient and Renaissance Italy. As painter to the Spanish court Velázquez encountered great Italian pictures in the royal collection, but the arrival of Rubens – one of the greatest exponents of Italianate art – would surely have increased Velázquez's desire to see Rome for himself. In 1629, at Rubens's prompting, Philip IV granted Velázquez leave to travel to Italy, where he remained for eighteen months, spending most of his time in Rome. The stylistic impact on the artist of the pictures he saw was considerable, but unravelling exactly which paintings Velázquez executed before, during and after this trip is still a matter of debate.

4 In 1629, with a generous bursary from the king, Velázquez travelled to Italy to study art. *Apollo at the Forge of Vulcan* was painted while the artist was in Rome. The mythological subject, taken from the ancient Greek poet Ovid, depicts the moment when Apollo the sun god, arrives at the forge of Vulcan, the god of the Underworld, to tell him that his wife, Venus, has been unfaithful. Although the treatment of the muscular figures clearly shows Velázquez responding to the idealised male nudes of classical sculpture and Renaissance painting in Rome, his vision of the mythological world is highly idiosyncratic and distinctly un-Italian. The whole scene is infused with Velázquez's insistent naturalism. The forge itself is littered with beautifully observed tools, anvils and pieces of burnished armour that Velázquez must have painted from life while the faces and expressions of the figures also suggests the use of real models. However it is Velázquez's lack of reverence for the ancient past that perhaps most clearly sets him apart from his contemporaries. The radiant Apollo, one of the most noble figures of the mythological pantheon, is shown as prim and rather effete young man while Vulcan, his eyes bulging, is a frankly comical depiction of an outraged smithy – his posturing body language clearly revealing his embarrassment at having the infidelity of his wife revealed in front of the lads.

Velázquez was 30 years old and an established artist by the time he visited Italy and *Apollo at the Forge of Vulcan* suggests he was able to keep the influence of its art and culture at a distance. But comparing the picture to a work he completed just before leaving Madrid, *The Feast of Bacchus*

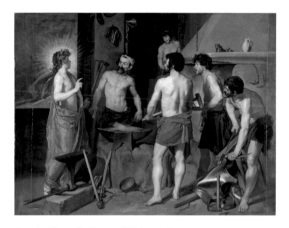

4 *Apollo at the Forge of Vulcan*, 1630
Oil on canvas, 223 × 290 cm
Museo Nacional del Prado, Madrid

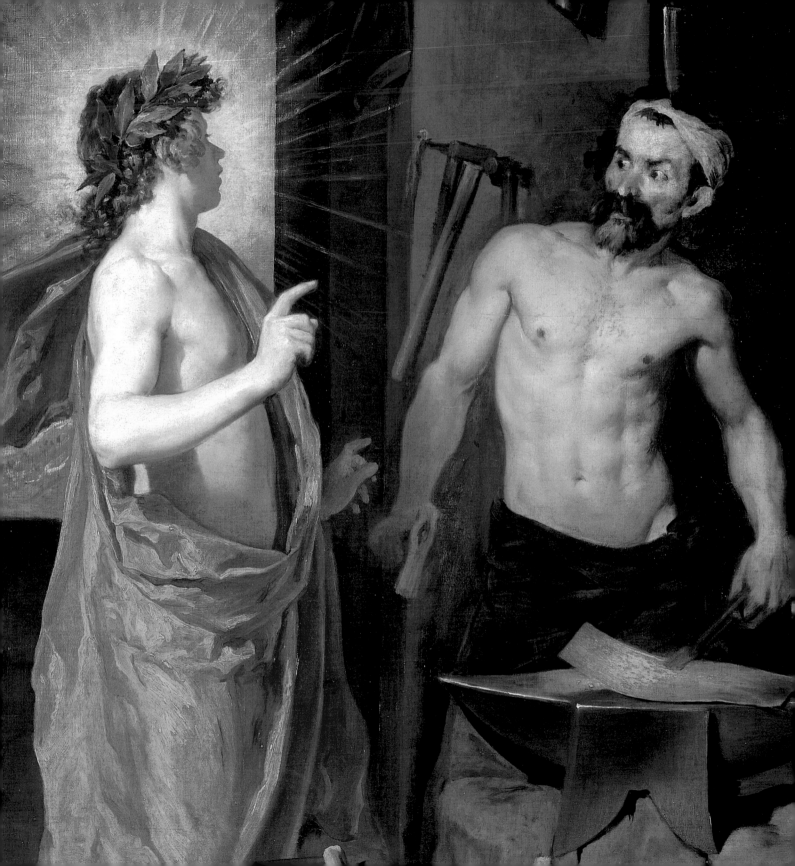

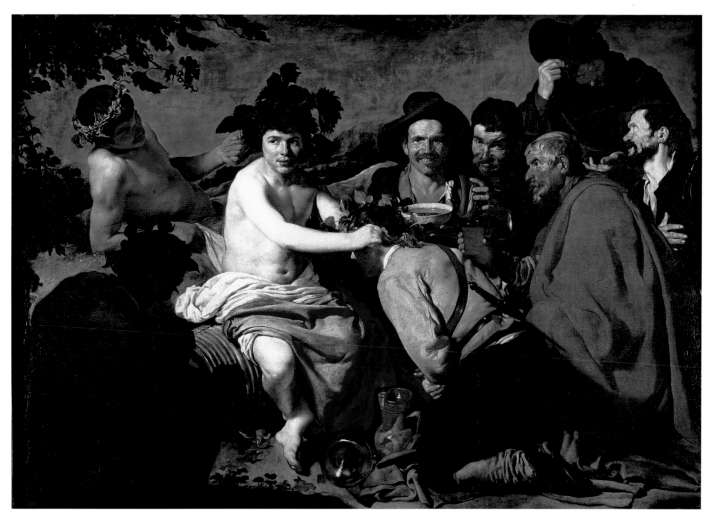

(*'Los Borrachos'*) (above), it is possible to see how Italian influences changed some of Velázquez's working methods – most notably his handling of perspective. In *'Los Borrachos'* where Bacchus, the mythological god of wine, is surrounded by a group of Spanish drinkers, everyone is crowded into a narrow, foreground space. The figures overlap and cut each other off. In the later picture Velázquez seems to have a much firmer grip on perspective, with each of his figures occupying their own space. While perspective was never something Velázquez used slavishly – the figure in the background of *Apollo at the Forge of Vulcan* who appears to be standing at a great height is a case in point – the artist's experience of Italy seems to have left him with a greater awareness of composition, and how to unify a composition to work as a whole.

The Feast of Bacchus ('Los Borrachos'),
about 1629
Oil on canvas, 165.5 × 227.5 cm
Museo Nacional del Prado, Madrid

VELÁZQUEZ'S CHIEF DUTY AS court painter was to make official portraits of Philip IV and the royal family, as these pictures played an important role in confirming the power and majesty of the Spanish throne. However, Velázquez's incredible talent for capturing personalities, along with his acute powers of observation, led him to paint some extraordinary images that give us intimate glimpses of the closed society of the Spanish royal household.

5 As Velázquez's biographer and former teacher, Francisco Pacheco, was proud to boast, Philip IV refused to sit to any other Spanish artist once he had appointed Velázquez a court painter in 1623. Velázquez stayed in the service of the Spanish crown for the rest of his life, and despite his many promotions within the court, his prime function remained the making of portraits of the royal family. This depiction of Philip IV, probably made a few years after Velázquez's return from Italy in 1631, shows the king in a particularly splendid costume of brown decorated with silver brocade over which he wears the badge of the Order of the Golden Fleece on a chain. It is thought the picture may record a special occasion as Philip IV was usually depicted in the simple black costume he wore on a daily basis. It is also one of the few pictures Velázquez signed.

In many respects Velázquez was following a well-established tradition for uncluttered, full-length royal portraits showing the monarch in three-quarters profile against a muted background. This restrained style of portraiture well suited the severe formality of the Spanish court which set the person of the king at a lofty distance from viewers, befitting to his royal status and divine right to rule. During his reign Philip IV was styled as the 'Planet King' because at the time the sun was believed to be the fourth planet. Here Velázquez paints his king with a look of impassive majesty, and also with a radiant paleness. This is certainly an idealised portrait but one in which Velázquez made no attempt to hide Philip's long and protruding lower jaw or the drooping eyelids characteristic of the Habsburg dynasty. The king must also have accepted Velázquez's extraordinary treatment of his robes. In describing the rich embroidery in silver thread that cover Philip IV's breeches, tunic and cloak, Velázquez dispensed completely with the convention of depicting royal clothes in meticulous detail. Instead he

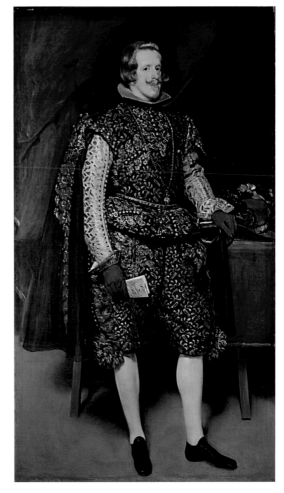

5 *Philip IV of Spain in Brown and Silver*, probably 1632
Oil on canvas, 195 × 110 cm
The National Gallery, London

used an extremely sketchy technique of loose swirls and thick dabs of paint that, when viewed close up, seem to make little sense at all. Philip IV must have appreciated how, when viewed at a distance, the artist's sketchy marks captured the play of light on costly, silver-encrusted fabric in a way that was far more dazzling to the eye than painstaking brushwork.

6 The 1630s were a particularly opulent time in the life of the Spanish royal court. In 1633 building work began on the *Buen Retiro*, a new palace just outside Madrid, especially designed for lavish entertainments. In part to justify the enormous expense to a public already overburdened with taxes, a great chamber, known as the Hall of Realms, was built within the palace, in which state ceremonies could take place. Velázquez was put in charge of the decorative scheme for this hall and among the outstanding pictures he painted for it was a group of equestrian portraits of the royal family. To either side of the door, opposite the throne, Velázquez positioned images of Philip IV (page 22) and Queen Isabella. Over the doorway, appearing to leap above the head of the gathered courtiers, he placed *Prince Baltasar Carlos on Horseback* in which the young heir to the throne – at this date only about 6 years old – sits confidently on a charging pony. With great poise Baltasar Carlos fixes us with a level gaze. In one hand he holds up the commander's baton while with the other he deftly holds the reins. With the wind catching the golden tassels of his commander's sash he appears, as one commentator has put it, the personification of the fresh surge of energy needed to reinvigorate the ailing Habsburg dynasty. The truth was that despite the claims for military prowess made by the pictures in the Hall of Realms, Spanish power in Europe was on the wane.

Prince Baltasar Carlos on Horseback is one of the best preserved of Velázquez's works and it shows how, by the mid 1630s, his technique had become extremely light and sketchy. When viewed close to, the picture is reminiscent of a giant oil sketch, with passages of extremely thinly applied paint – as in the prince's face – contrasting with details, such as the snow-capped mountains, where long, flowing individual brushstrokes are clearly visible. The colours are much brighter than in works of the 1620s, and with Velázquez using a white ground beneath the paint, the prince does not loom out of darkness, but instead appears to be bathed in sunshine.

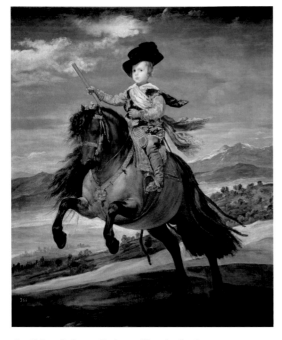

6 *Prince Baltasar Carlos on Horseback*, 1634–5
Oil on canvas, 209 × 173 cm
Museo Nacional del Prado, Madrid

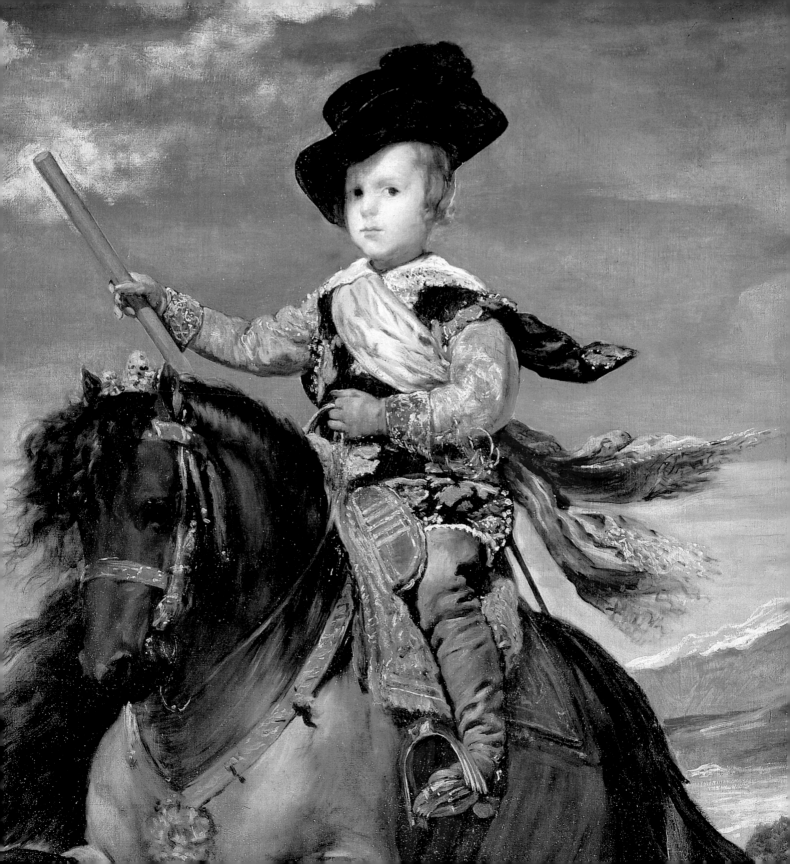

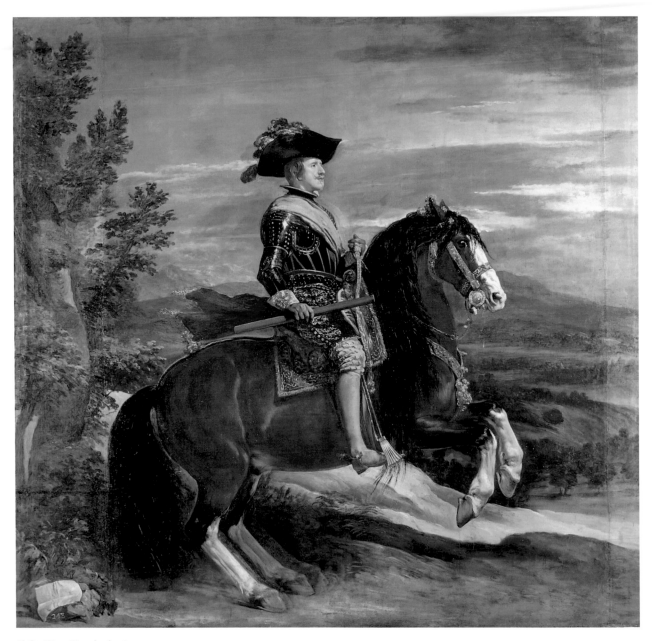

Philip IV on Horseback, 1634–5
Oil on canvas, 301 × 318 cm
Museo Nacional del Prado, Madrid

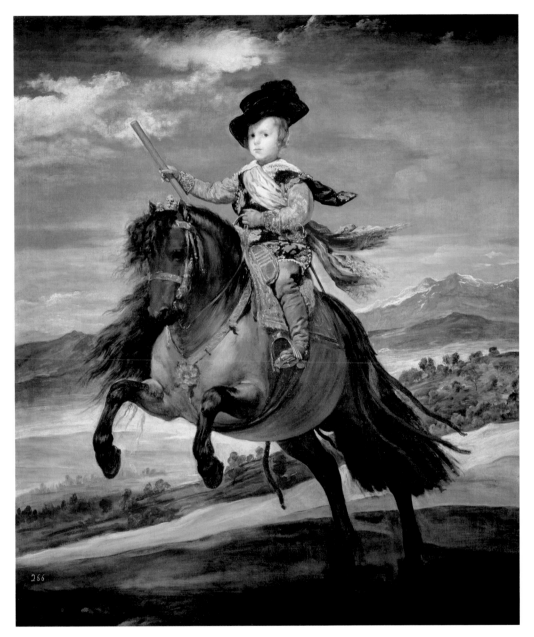

6 *Prince Baltasar Carlos on Horseback*, 1634–5
Oil on canvas, 209 × 173 cm
Museo Nacional del Prado, Madrid

7 *Philip IV hunting Wild Boar (La Tela Real)*,
 1636–8
 Oil on canvas, 182 × 302 cm
 The National Gallery, London

7 This picture, the only full-scale landscape Velázquez is known
to have painted, depicts a favourite royal pastime at the Spanish
court – the hunting and baiting of wild boar. This sport was not
pursued in open park-land, but in the highly controlled environment
of a space encircled by a *tela* or canvas. Within what was known as
the *counter-tela* the royal hunting party and their hounds could bait
and kill the animals while being watched by female members of the
court from the safety and comfort of their carriages. It was an activity
chiefly designed to show off the king's skill as a horseman, and was
immensely costly as the actual *tela real* of the picture's title refers
to a second, much larger enclosure that we can see the beginnings
of in the upper half of the picture. The wild beasts were gathered
there before being driven towards the royal party.

Unlike other depictions of the hunt, in which artists concentrated
on the royal protagonists, here Velázquez takes the distant viewpoint
of the casual observer. With a few deft strokes many of the tiny
figures within the *counter-tela* become recognisable portraits. But
it is the hangers-on and less important members of the court who
have gathered outside the canvas on which Velázquez concentrates
his attention. Every part of the foreground space in which these
figures mill about seems to feature a miniature drama or narrative.
On the far left, for example, we see some of the young men in charge
of the royal hounds, one of them tending to a wounded animal under
the shade of a tree. Just to the right a group of poorly dressed workers,
possibly exhausted from setting up the event, relax and drink, while
to the right of them stand a group of three exquisitely dressed
gentleman who are ignoring the hunt altogether and are shown
deep in conversation – the one in the centre gazing directly up to
our raised vantage-point.

Although he rarely painted landscape pictures, Velázquez has made
a very accurate depiction of the countryside outside Madrid, capturing
its patches of bare, parched soil and dense clumps of trees. Perhaps it
was because of the accuracy of the view, both in terms of the landscape
as well as the daily life and variety of court society, that *La Tela Real*
was copied for the royal palace in Madrid. It is thought this original
was hung in the newly refurbished Torre de la Parada, the royal hunting
lodge, in which the king's skill as a huntsman was celebrated by a
variety of artists.

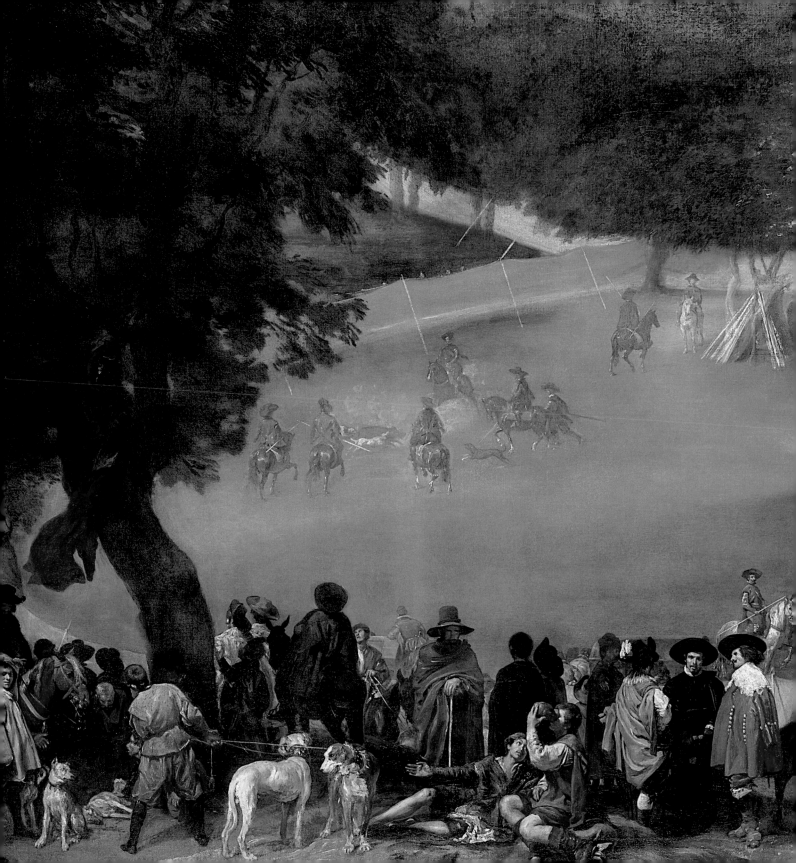

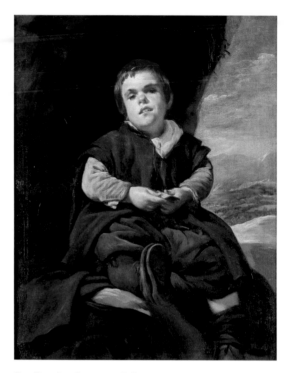

8 *Francisco Lezcano*, 1638–40
 Oil on canvas, 107 × 83 cm
 Museo Nacional del Prado, Madrid

8 The Spanish royal court in which Velázquez lived and worked was very insular. There was little contact with society at large and even the servants attending on the royal family were themselves mostly members of the aristocracy. However, there was one group of courtiers who were brought in from outside: entertainers. These included a large number of men, women and children who were physically and mentally challenged. The young man in this exceptional portrait from the late 1630s is thought to be Francisco Lezcano, a dwarf employed for the amusement of Philip IV's son and heir, Prince Baltasar Carlos. Unlike Velázquez's earlier depiction of *Mother Jerónima de la Fuente* (see page 10) in which he depicted a personality alive with fierce intelligence, here he shows us a youth whose mental faculties are impaired. Painting with very diluted pigments in a way that gives Lezcano's face a kind of hazy distance, Velázquez depicts his subject with his head tipped back and a half-smile playing on his lips. But his small eyes, in which no highlight glints, suggest a vacancy of mind – a mental state symbolised by the deck of cards he idly shuffles in his hands. In this intensely searching portrait Velázquez does not shy away from painting what he sees. With deft strokes he records Lezcano's scrappily cut fringe, the twist of his deformed neck and the shortness of his bandy legs, one of which is stuck out in front of him while the other dangles down with its stocking drooping. But as much as Velázquez sees, he does not judge. And what comes across to us, even from a distance of over 350 years, is Lezcano's presence as a human being worthy of respect.

It may seem exceptionally cruel to us now that someone like Lezcano was hired to be laughed at or to highlight, by contrast, the supposed mental and physical perfections of the royal family. But in Velázquez's day the mentally challenged were venerated as being particularly close to God. In the pious atmosphere of the Spanish court they were revered as speakers of the truth, one result being that they could act and behave with a freedom unthinkable even to the most senior members of the royal household. Perhaps this is one of the reasons Velázquez took such interest in figures like Lezcano and the other dwarfs and jesters he depicted. Their privileged status allowed him to develop an intensely honest, informal and penetrating style of portraiture that court etiquette simply wouldn't permit in his portrayal of the royal family.

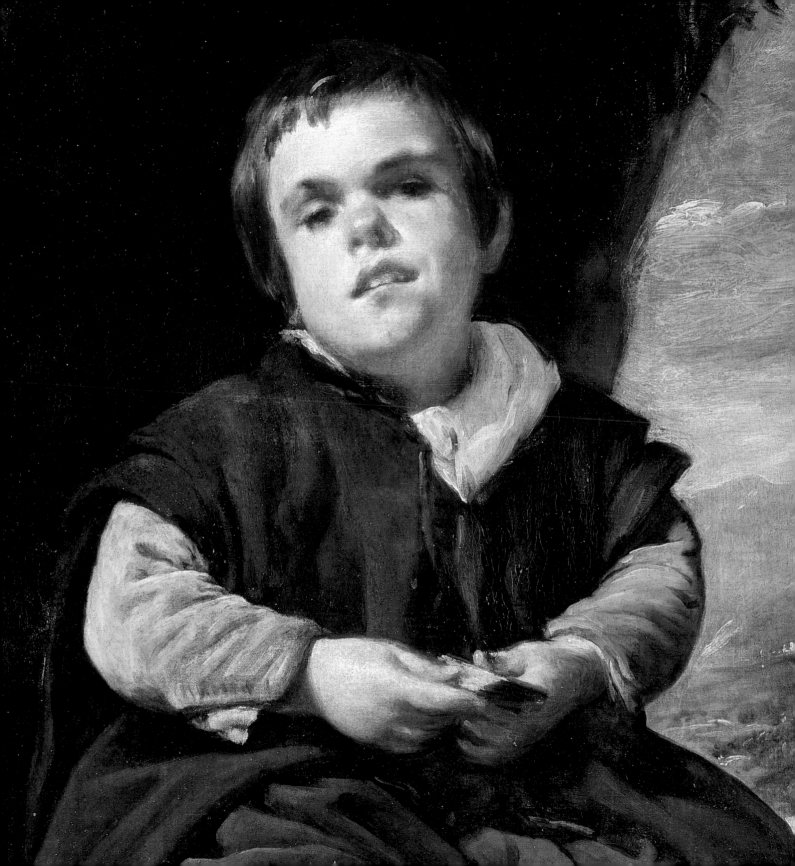

THE LATER MYTHOLOGIES

FEW SPANISH ARTISTS IN Velázquez's day tackled subjects drawn from ancient mythology. But the Spanish royal collection contained many great depictions of the classical gods by both Italian Renaissance artists and Rubens – Velázquez's only rival for Philip IV's patronage. Velázquez's late mythologies seem to be his highly personal response to these pictures.

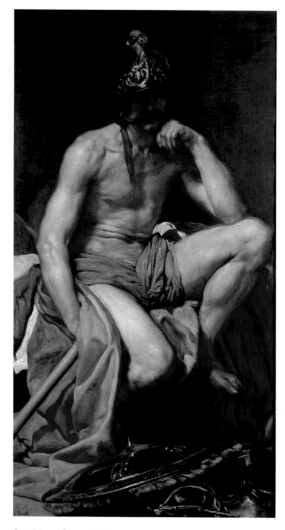

9 *Mars*, about 1638
Oil on canvas, 179 × 95 cm
Museo Nacional del Prado, Madrid

9 The naturalism and humour Velázquez brought to his depiction of the mythological subject *Apollo at the Forge of Vulcan* (see page 15) is very much in evidence in this image of Mars, the Roman god of war. Here, instead of presenting us with an idealised and virile hero we are shown an extraordinarily convincing depiction of a man whose muscles are beginning to sag and whose flesh is turning loose and soft. Mars sports a luxuriant moustache – a sign of valour in Spain – but his gilded helmet looks at least a couple of sizes too large for him. He stares out gloomily from beneath its hazy shadow, his chin resting on one grizzled fist in a pose traditional to depictions of melancholy. He is perhaps contemplating past victories although his baton of command – exactly the sort held aloft triumphantly in Velázquez's portrait of *Prince Baltasar Carlos on Horseback* (see page 20) – is now a useless prop while the rest of his armour lies discarded at his feet.

Apart from the brilliance of Velázquez's depiction of an ageing body, one of the fascinating aspects of this picture is the insight it gives us into the artist's working methods. It seems Velázquez never made elaborate preparatory drawings like most other painters of his age, but preferred to work directly onto the canvas, making alterations to his composition as he went along. Because certain of the pigments he used to paint *Mars* have become transparent with age, it is now possible to see where he changed his mind. On the god's raised thigh, for example, there is a distinct change of skin-tone that marks the area that Velázquez initially covered with the blue cloth Mars wears over his hips. And today, under the rose-pink drapery that covers Mars' lowered hand on the left, more blue cloth is becoming visible. By reducing the area of blue, a cool colour, and adding the rose-pink, Velázquez gave the picture an increased vibrancy and warmth – two aspects of *Mars* it would be hard to imagine the picture without.

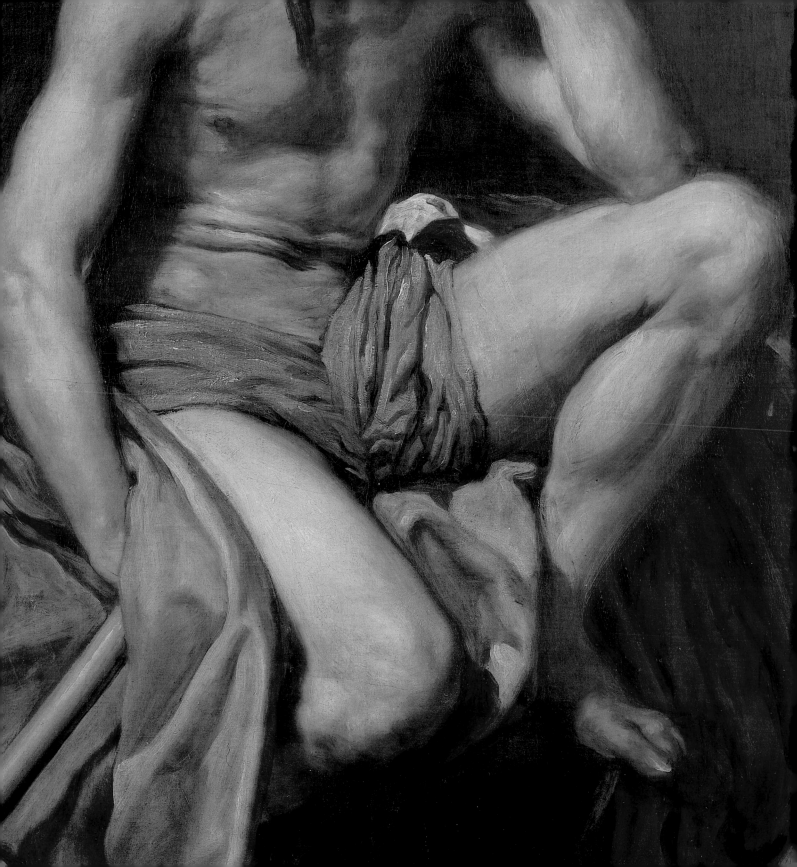

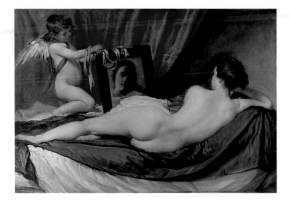

10 *The Toilet of Venus ('The Rokeby Venus')*, 1647–51
Oil on canvas, 122.5 × 177 cm
The National Gallery, London
Presented by The Art Fund, 1906

10 The female nude was very rarely depicted by Spanish artists in the seventeenth century. Velázquez's teacher, Francisco Pacheco, who served on the Spanish Inquisition, thought it indecorous for an artist to paint any more than the face and hands of a woman from life. But in *The Toilet of Venus*, also known as '*The Rokeby Venus*' after the British collection in which it was once housed, Velázquez was reinterpreting a distinctly Italian form of art. One of the great sixteenth-century painters Velázquez admired, and whose work was very well represented in the Spanish royal collection, was the Venetian artist Titian. Titian frequently depicted sensuous female nudes in the guise of Venus, the classical goddess of Love. In some pictures he showed her reclining for the admiration of the viewer's gaze, in others she appeared looking at herself in a mirror held by her son, the winged god Cupid. Velázquez's *Toilet of Venus* combined the two types and in spite of the supernatural detail of Cupid's wings, seemed to bring Titian's renowned sensuousness to the depiction of a real woman.

Velázquez's use of finely ground pigments heavily diluted with oil has reached such a level of virtuosity in this picture that he is able to suggest the soft body of goddess, and the sweep of her brown hair, with minimal amounts of paint. The haziness apparent in the portrait of *Francisco Lezcano* and *Mars* (pages 26–8) has now become such that the contours of Venus' face and her reflection in the mirror are indistinct in the extreme. Yet it is precisely this lack of focus that gives us the sense of being in the presence of a living, breathing woman; despite the fact that on closer inspection it becomes clear that Velázquez altered his model's anatomy – elongating her back, for example – to achieve the effect he was after.

We know that this picture was painted for a private patron, Gaspar de Haro, the marquis of Eliche, who was a wealthy libertine and art collector. He was also, interestingly, the person who arranged the elaborate musical plays performed for the Spanish royal court in which actresses played the parts of gods and goddesses. It has been suggested that Velázquez's Venus could be a depiction of one of Eliche's leading ladies, although the idea that it may show one particular woman scandalously famous for sleeping on black taffeta sheets must be discounted. Recent technical examination of this painting has revealed that the grey cloth on which Venus reclines was purple when first painted. The pigment has faded and decayed. Indeed, it may be that a number of Velázquez's pictures were very much brighter than they appear today.

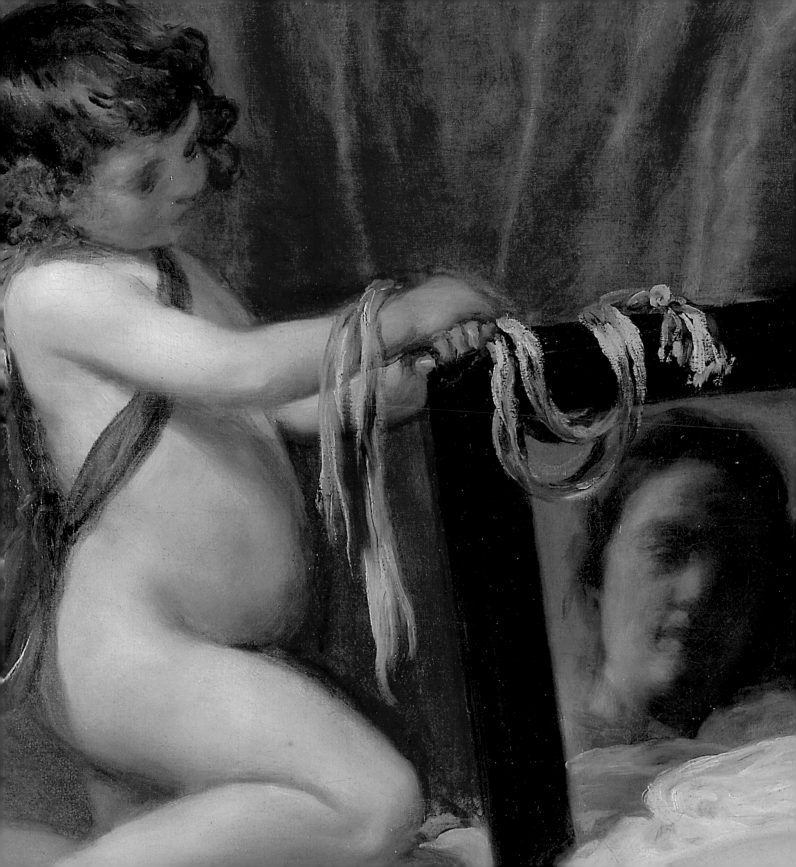

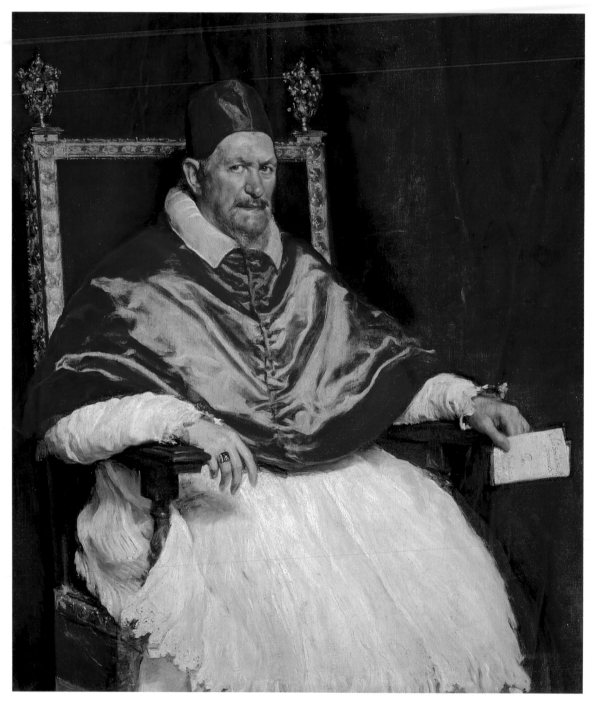

Pope Innocent X, 1649–50
Oil on canvas, 140 × 120 cm
Galleria Doria-Pamphilj, Rome

VELÁZQUEZ PAINTED VERY LITTLE in the last two decades of his life – but produced some of his greatest portraits. His ability to capture a living likeness won him universal acclaim during his second trip to Italy in 1649–51, while back in Madrid, the dynastic fears of the Spanish throne led to a spate of brilliant royal portraits, most particularly of the king's marriageable daughters, where Velázquez took his loose painting style to new extremes.

11 Throughout the 1640s Velázquez was given a series of promotions at court. These not only increased his income, his status, and his daily proximity to the person of the king – the ambition of any courtier – but they gave him new responsibilities. One of these was his role overseeing the design and decoration of the major renovation of the Alcázar, the royal palace in Madrid. At the very end of 1648 this project led Philip IV to send Velázquez to Italy for a second time on a mission to acquire pictures and sculpture for the palace. It was the beginning of a trip that lasted almost three years in which, in contrast to his first trip to Italy, Velázquez became closely involved with Italian patrons and artists.

This portrait of Monsignor Camillo Massimo records Velázquez's friendship with a renowned art collector. Despite showing Massimo in the official peacock blue robes of his senior post in the papal household, there is an informality to the image in which with minimal modelling Velázquez records Massimo's full mouth, plump jowls and heavily lidded eyes. Patrons in Rome, who were used to smooth, carefully finished pictures, were astonished by Velázquez's almost magical ability to suggest living people with a technique that not only drew attention to itself as a series of paint strokes, but also coalesced perfectly at a distance to reproduce the world of appearances.

Perhaps the greatest expression of this technique in a portrait is Velázquez's depiction of *Pope Innocent X* (opposite) – considered by many to be the greatest portrait of his career. The Pope was known to be a watchful and mistrustful man who in spite of being 67 when this portrait was painted, was renowned for his vigour and the iron grip he held on his office. All these aspects of his personality radiate from Velázquez's portrait with electrifying force. The great regard this painting received may have led directly to Velázquez's invitation

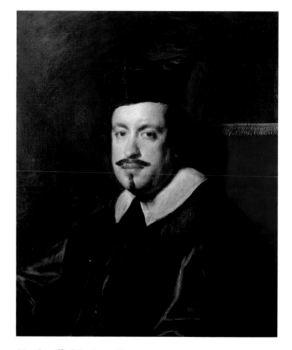

11 *Camillo Massimo*, 1650
Oil on canvas, 74 × 58.5 cm
Kingston Lacy, The Bankes Collection
(The National Trust)

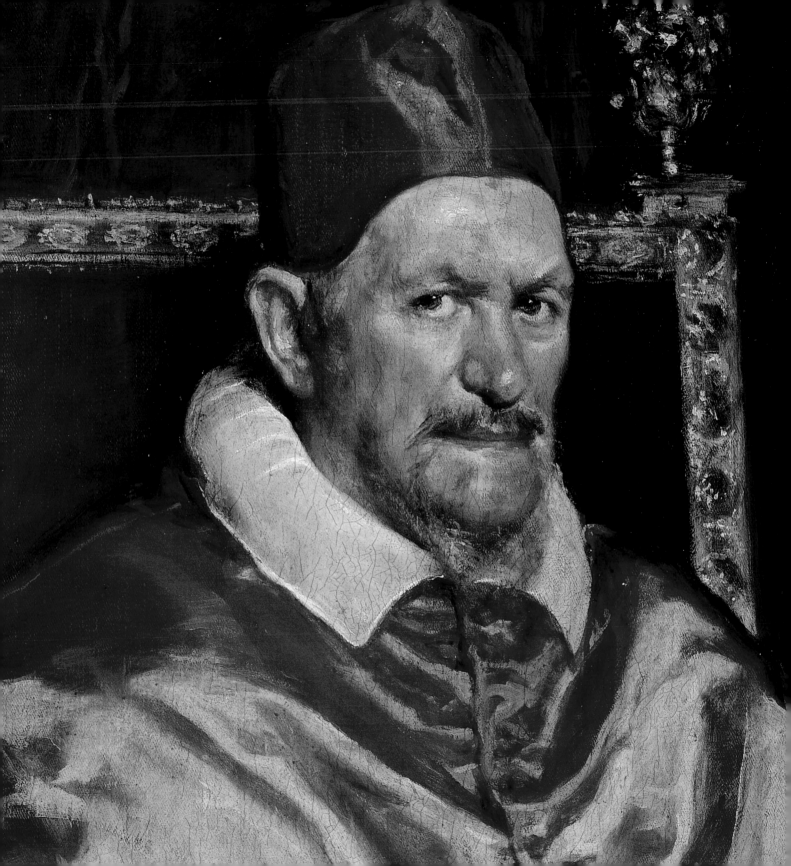

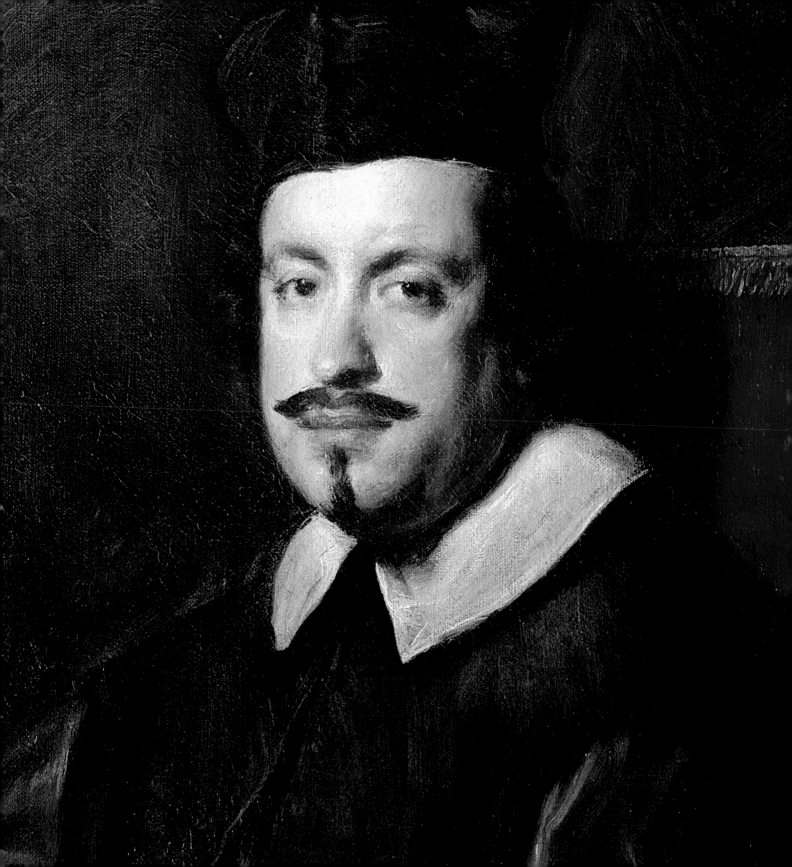

to join two of Rome's prestigious academies of painting in early 1650. Certainly the universal adulation that greeted his work in Rome must have been thrilling for the artist, who could now see that his exulted position and fame at the Spanish court also had an international dimension.

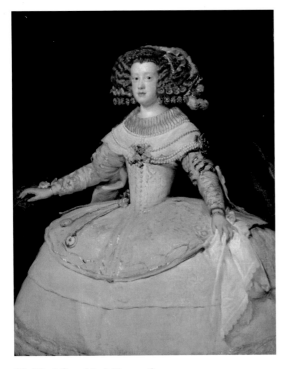

12 *The Infanta María Teresa*, 1652
Oil on canvas, 127 × 98.5 cm
Kunsthistorisches Museum, Vienna

12 Following the death of Prince Baltasar Carlos in 1646, María Teresa became the last survivor of six children born to Philip IV and Queen Isabella. Without a male heir to the throne of Spain, her marriage became a matter of great diplomatic concern, and so when the princess had her twelfth birthday and became of marriageable age, Velázquez and the assistants in his workshop were busy producing her likeness for the major royal courts of Europe. The extent to which Velázquez himself, rather than his workshop, was involved in royal portraits varied depending on the importance of the recipient. However, for this picture destined for María Teresa's illustrious uncle, the Holy Roman Emperor Ferdinand III, only the hand of the master was good enough.

As in *Philip IV of Spain in Brown and Silver* (see page 19) here Velázquez records the rigid formality of the princess's pose and her stiff clothes with a remarkably informal technique. A series of rapid squiggles and sweeping strokes capture the curls and knotted ribbons of her wig, the red-trimmed folds of the ruff around her shoulders, her tightly corseted waist and the massive skirts of her dress held out by a crinoline. In some areas there is barely any paint at all while in others, such as the area of skirt fabric around the princess's draped handkerchief, the geometric pattern that is woven into the fabric is suggested subtly. This patchy approach to detail demonstrates that Velázquez intuitively understood what only modern science has been able to verify, that humans grasp the appearance of things through a series of rapid glances. He seems to have known that we do not see things whole and in fine detail, which is perhaps why, even with only tiny encrustings of pigment or the barest changes in tone, Velázquez is able to suggest convincingly the silver-threaded embroidery on the princess's bodice, the lustre of her pearls and the childish sweetness of her face staring out from behind the thick make-up.

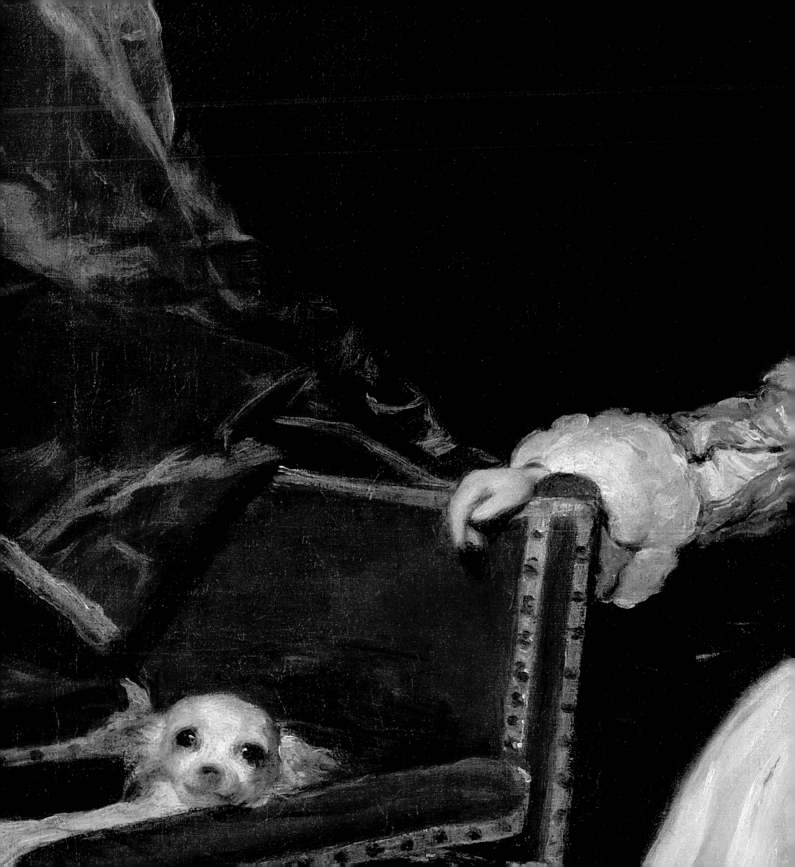

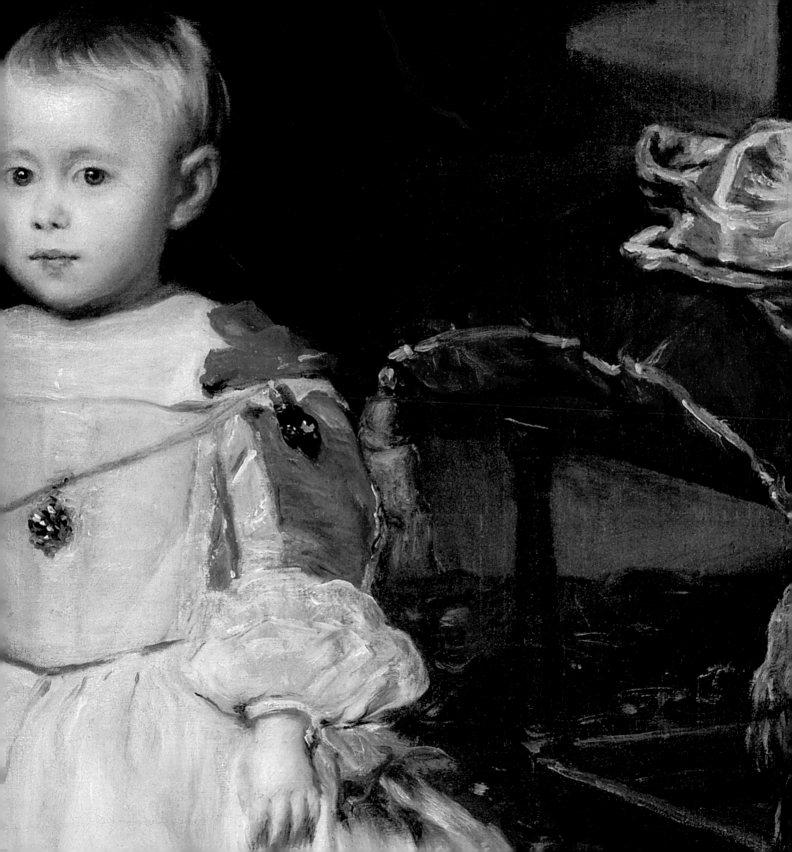

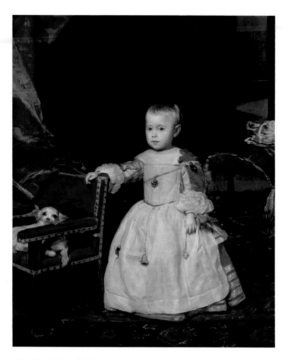

13 *The Infante Felipe Próspero*, 1659
Oil on canvas, 128.5 × 99.5 cm
Kunsthistorisches Museum, Vienna

13 King Philip IV had been reluctant to remarry after the death of Queen Isabella in 1644, but without an heir a crisis faced the Spanish throne. So when in 1657 his second wife, the young Mariana of Austria, gave birth to a son there was much rejoicing. This portrait shows the prince, Felipe Próspero, aged 2. He is dressed in skirts, as was the custom for infant boys, and adopts a suitably regal pose with his tiny hand resting on the back of a small chair. Despite the formal requirements of painting the Habsburg heir, Velázquez depicts his young subject with great charm. The little boy's white-blonde hair, bulging forehead and large, dark eyes are echoed in the appealing look of the lap-dog resting its chin on the chair's armrest. The diminutive stature of both prince and pet are suggested by the full-scale stool and cushion placed just behind them on the right.

Unfortunately the young prince was a victim of the Habsburg tradition of marrying within close family. His mother was Philip IV's niece and from the outset he was a weak and sickly child. Velázquez records his frailty in his pale features and delicate frame and also captures something of the sombre mood of the court in the 1650s. Unlike Velázquez's earlier depictions of the former heir, Baltasar Carlos, in which the little prince was optimistically shown as a commander-in-chief in the waiting, here there is no military sash or baton of command. Instead, a gloomier atmosphere of anxiety is suggested: Felipe Próspero is shown bedecked with traditional amulets and charms intended to ward off the evil eye and sorcery. Sadly, they were of little use as the prince did not survive to his fifth birthday.

14 The Infanta, or princess, Margarita was the first child born to Philip IV and his second wife Mariana of Austria. In 1659 Velázquez painted this portrait of her aged about 8 along with *The Infante Felipe Próspero* to send to the German Emperor Leopold I. Margarita had been betrothed to her cousin Leopold at birth, and regular portraits of her were sent to the imperial court in Vienna for the Emperor to view her progress. Margarita was said to be exceptionally beautiful as a child, a claim borne out in this picture. Velázquez records her pale skin, large eyes and small but full mouth

and he seems to have particularly delighted in her golden hair, which has yet to be covered by the stiff wigs so fashionable among the grown women of the Spanish court. In fact, he appears to use her hair's natural sheen and frizz as a contrast to the heavy golden brocade decorating her blue velvet dress and the links of the broad gold chain she wears across one shoulder.

For many years Margarita was the only one of Philip IV's new family to survive, and it was perhaps because of her preciousness that she figures as the centre of attention in Velázquez's greatest masterpiece, *The Family of Philip IV ('Las Meninas')* or *The Maids of Honour* (page 42). Painted in 1656, when the Infanta was about 5 years old, it shows her standing in one of the grand rooms of the Alcázar attended by two young female servants and an entourage including a male and female dwarf, a sleeping royal hound and, in the shadows on the right, a woman in a nun's habit with a male retainer. Behind these figures our eyes are drawn deep into the shadowed recesses of the room, where on the back wall a courtier is glimpsed through an open door next to a mirror reflecting the faces of the king and queen.

Velázquez painted the whole scene as if he was standing in front of it although, importantly, he himself appears on the left, standing before a massive canvas, palette and brush in hand. There are volumes written about this complex and intriguing work, all searching for answers to the innumerable questions it raises. Does Velázquez show himself painting *'Las Meninas'*? Does the mirror on the back wall reflect the presence of the king and queen in the space outside the picture occupied by the viewer? Or could it reflect the canvas in front of Velázquez? These matters may never be settled permanently, but what remains significant is the fact that Velázquez shows himself at work in the company of the royal family. Since his arrival at the Spanish court Velázquez's brilliance as a painter and designer had allowed him to rise through the ranks to achieve the most senior post of Chamberlain to the royal household. His many courtly duties meant that by the time he created *'Las Meninas'* he barely had time to paint at all – but by showing himself as an artist in royal company, Velázquez made the most adamant statement of his career that painting should be considered a noble art worthy of the highest esteem.

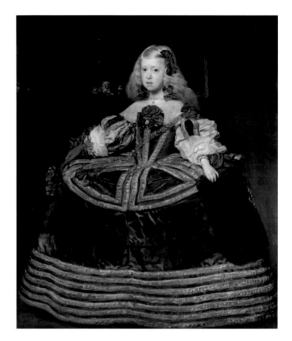

14 *The Infanta Margarita Teresa in a Blue Dress*, 1659
Oil on canvas, 127 × 107 cm
Kunsthistorisches Museum, Vienna

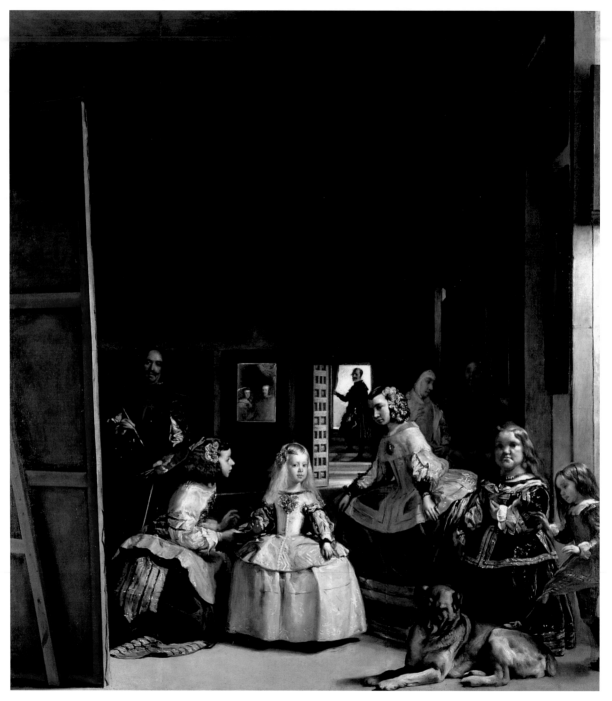

The Family of Philip IV ('Las Meninas'), 1656
Oil on canvas, 318 × 276 cm
Museo Nacional del Prado, Madrid

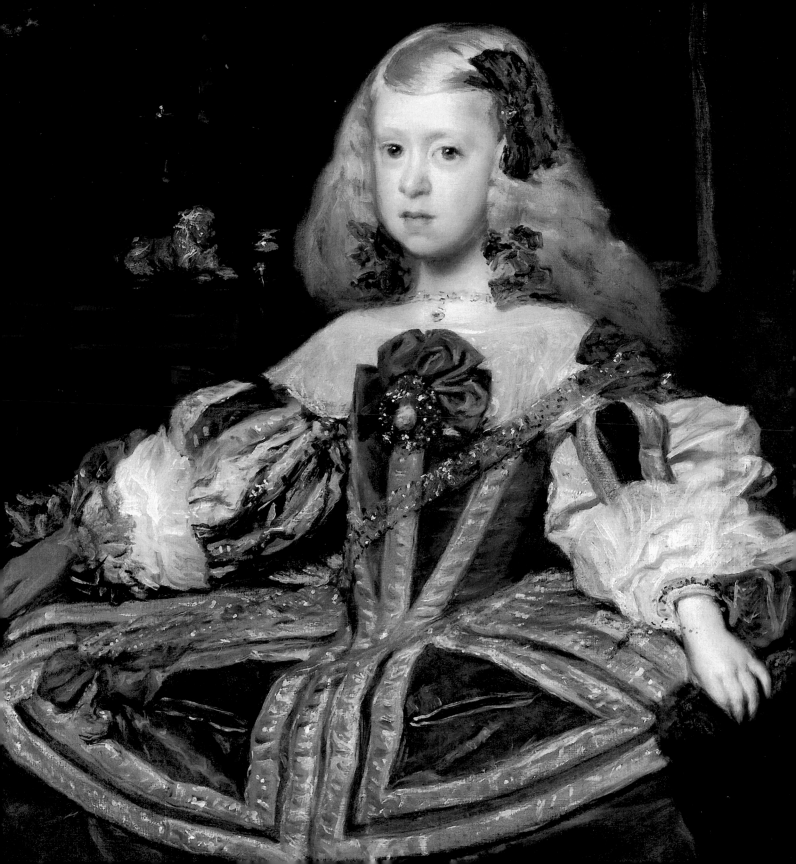

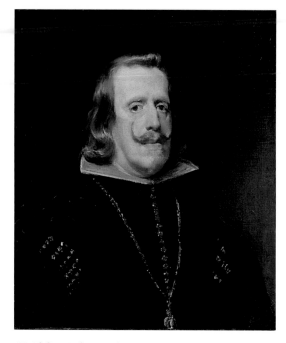

15 *Philip IV of Spain*, about 1656
Oil on canvas, 64.1 × 53.7 cm
The National Gallery, London

15 Philip IV rarely had his portrait painted in the later years of his reign. As he once explained to a confidante 'I am not inclined to submit myself to the phlegmatic temperament of Velázquez, and … do not want to see myself growing old.' By 'phlegmatic' the king meant cool and unemotional although, if accounts are to be believed, Philip IV had once voluntarily spent long hours sitting for the painter and very much enjoyed his company. This portrait is the last Velázquez painted of the king. The three-quarter pose, the shining fall of wavy hair and the upswept moustache remain the same as in earlier portraits but, behind the mask of the king's impassive expression, Velázquez notes the unmistakable signs of age and care in the monarch's drooping eyelids and nascent double chin. Certainly there had been much in Philip's later years to cause him grief. The unsuccessful military campaigns of the late 1630s and early 1640s, by which the Spanish crown lost sovereignty over Portugal and Artois in France, were followed by personal and dynastic tragedies with the deaths of the king's first wife and son. These troubles caused Philip to retreat still further into the protected world of the court where, with the loyal support of Velázquez, he could continue to refurbish his palaces so that the Spanish royal collection – if not Spain itself – might rank among the greatest in the world.

Philip IV honoured Velázquez as a painter and as a person of worth. Over the 30 years the artist remained in his service Philip's promotions made Velázquez part of his personal circle at court. He also went to considerable lengths to ensure Velázquez's acceptance into the Order of Santiago in 1659, by which the artist was able to fulfil a life-long ambition to become a Spanish nobleman. When in August 1660 Velázquez was suddenly taken ill, Philip sent his personal physician to attend him, and he is even reported to have personally visited Velázquez in his hour of death.

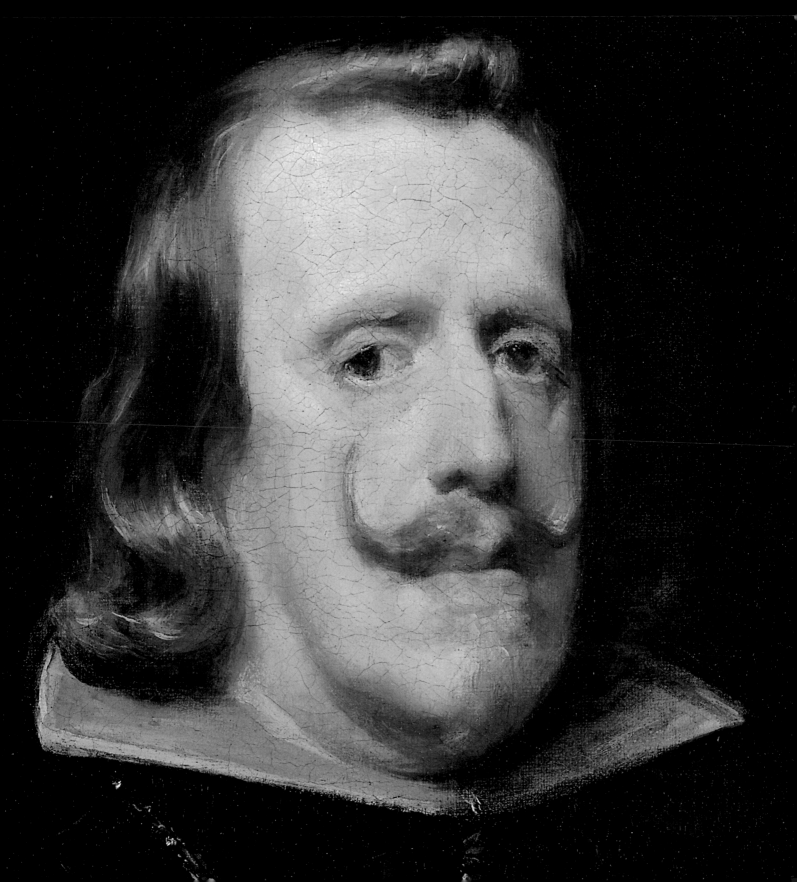

CONCLUSION

WHEN VELÁZQUEZ DIED ON 7 August 1660 at the age of 61, he was buried with all the pomp befitting his status as a senior courtier and chief painter to the king. However, following the death of Philip IV five years later, it was not long before Velázquez's work fell out of favour. By the eighteenth century he was almost forgotten – a situation worsened in 1734 by the loss of a large number of his pictures in a fire that destroyed the Alcázar.

In the nineteenth century, however, interest in Velázquez revived. The upheavals caused by the Napoleonic Wars in Europe saw many of his pictures dispersed. Collectors, particularly in Britain, took great interest in his work – a situation which today means that the National Gallery in London has the finest group of Velázquez's paintings outside of Spain. Displays of Velázquez's work at the newly opened Museo Nacional del Prado in 1819 and the Galerie Espagnole in the Louvre in 1848 brought the artist's genius to new generations. Idolised for his unflinching naturalism and loose technique by artists such as Edouard Manet, Velázquez played an essential role in the birth of Impressionism, and his influence continued in the twentieth century through artists as diverse as Picasso, Dalí and Francis Bacon. Over the last forty years Velázquez's gifts as an intuitive and intellectual philosophiser on the nature of art have seen a proliferation of writing on his work – most particularly on his masterpiece *'Las Meninas'* (see page 42). New research has also revealed more about his life as a courtier and curator of the Spanish royal collection, but perhaps it is face-to-face with his paintings, when we as viewers can appreciate the magic of a technique that enables near-abstract marks of paint to capture the essence of seeing and experiencing the world, that we can best understand why Velázquez ranks as one of the greatest painters of all time.

Opposite: *The Family of Philip IV ('Las Meninas')*, 1636, (Self portrait, detail of page 42)

FURTHER READING

J. Brown, *Velázquez: Painter and Courtier,*
New Haven and London 1986

J. Brown and C. Garrido, *Velázquez:
The Technique of Genius,* New Haven and
London 1998

Velázquez, D. Carr, X. Bray, J.H. Elliott,
L. Keith, J. Pórtus, exh. cat.,
The National Gallery, London 2006

D. Davies and E. Harris, *Velázquez in Seville,* ed.
M. Clarke, exh. cat., National Gallery of
Scotland, Edinburgh 1996

E. Harris, *Velázquez,* London and Oxford 1982

PHOTOGRAPHIC CREDITS

EDINBURGH
© National Galleries of Scotland. Photo
Antonia Reeve, Edinburgh: page 8 (detail 9)

LONDON
© The National Gallery, London: pages 14
(detail 12–13), 19 (details 2 and 18), 24 (detail 25),
30 (detail 31) and 44 (detail 45)

MADRID
© Museo Nacional del Prado, Madrid: pages 17,
42 (detail 48), 22, 15 (detail 16), 20 and 23 (detail
21), 26 (detail 27) and 28 (detail 29)

PRIVATE COLLECTION
© Photo courtesy of the owner: page 10 (detail 11)

ROME
© Galleria Doria-Pamphilj, Rome: page 32
(detail 34)

SWINDON
The Bankes Collection, Kingston Lacy,
The National Trust © NTPL. Photo
Derrick E. Witty: page 33 (detail 35)

VIENNA
Kunsthistorisches Museum, Vienna
© KHM, Vienna: page 36 (detail 37), page 40
(detail 38–9), page 41 (detail 43)

This book was published to accompany the
exhibition *Velázquez* at the National Gallery,
London, 18 October 2006 – 21 January 2007.
© 2006 National Gallery Company Limited

Sponsored by

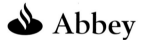

First published in Great Britain in 2006 by
National Gallery Company Limited
St Vincent House
30 Orange Street
London WC2H 7HH
www.nationalgallery.co.uk

Publisher Kate Bell
Project Editor Tom Windross
Designer Reena Kataria
Picture Researcher Kim Klehmet
Production Jane Hyne and Penny Le Tissier

Colour reproduction by DL Repro Limited
Printed and bound in Hong Kong by
Printing Express

ISBN 10: 1 85709 313 5
ISBN 13: 978 1 85709 313 1
525338

British Library Cataloguing-in-Publication Data
A catalogue record is available from the
British Library

All measurements give height before width

Front cover: *The Toilet of Venus ('The Rokeby
Venus'),* page 20 (detail)
Page 2: *Philip IV of Spain,* page 44 (detail)
Page 4: *The Infanta María Teresa,* page 20
(detail)